THE APERTURE HISTORY OF PHOTOGRAPHY SERIES

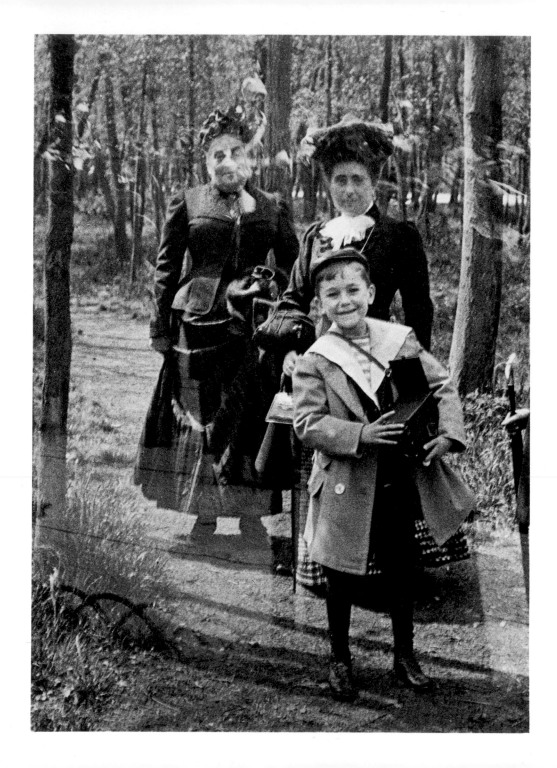

Jacques-Henri Lartigue

APERTURE

779

The History of Photography Series is produced by Aperture, Inc., under the artistic direction of Robert Delpire. *Jacques-Henri Lartigue* is the fifth book in the series.

Aperture, Inc., publishes a periodical, portfolios and books to communicate with serious photographers and creative people everywhere. A complete catalogue will be mailed upon request. Address: Elm Street, Millerton, New York 12546.

Manufactured in the United States of America.

Looking at the photographs of Jacques-Henri Lartigue is, for many people, like going home. For the era he traced so lovingly with his ingenuous camera, the years from 1900 to 1920, represent a special period in western social history, a matchless hinge between a dying epoch and the present day.

In America, Walter Lord christened this period "The Good Years"—the decade and a half between the turn of the century and the time when this nation first devoted itself to the task of making the world safe for democracy. The French called it "La Belle Époque"—a soft and sunlit interval of peace whose incomprehensible end was the spectacle of their glory marching off to be ground up and buried forever in the mud. Happily for all of us, Lartigue's eye was simply not tuned to any of life's horrors and ugliness. Though he entered the army when the war broke over Europe, and served as a pell-mell staff car driver for a series of generals, there is no evidence—either in this book or in the other Lartigue photographs which have been published or exhibited—that he ever let his camera look at death or destruction. Rather, his vision has been a joyful, exuberant one, and has remained so over the eighty-three years of his life, through two great wars and a world-wide depression.

Several of the pictures in this book were taken after World War I, but they are of a piece with the others—and with all the rest of Lartigue insofar as we have been privileged to glimpse it. This glimpse, a mere droplet in the ocean of photographs taken by this extraordinary man, reveals a concern only for beauty, elegance, excitement, for the moment of delicious satire, for good, old-fashioned fun. Look at the picture on page 71 of Lartigue's older brother, Zissou, taking off momentarily—

very momentarily—in one of the dozens of kite planes that he built and tried to fly during the time when all of France was seized by the giddy challenge of soaring into the sky. Does anything say more of the dreamlike excitement of that time, of the confidence and romanticism of the people? Or indeed of the sure eye and brilliant sense of timing of the sixteen-year-old photographer who not only captured the moment, but saw in it the combination of verve and marvelous farce that are part of so many of his other pictures?

"It was in a way a fairy-like epoch," Lartigue said in a recent interview, his blue eyes laughing the way they always seem to. "And above all there was a new magic adventure of which I dreamt at night and of which I fancied and talked: flying. Nowadays we find flying quite ordinary. But for me and for the young people of my time it was something fantastic, miraculous. All my beautiful dreams as a young boy happened in the air. I even convinced my tutor to take me to the aerodrome of Issy les moulineaux, where the first pilots tried to take wing—instead of giving me spelling lessons."

It was a wise bit of persuasion by Lartigue, and a wise acquiescence on the part of the tutor. For the spelling lessons never really took; in fact, no aspect of formal academic training left a dent in the young Lartigue, who never made it out of school. His dossier for a recent exhibit has, under the entry EDUCATION, the sole and vague comment "Secondary schools." This raises some fascinating questions about what may really be the proper schooling for highly energized, imaginative people with a creative flair who fit poorly into any institutional mold.

For Lartigue, fortunately, school never loomed as a threat, or even much of a reality. He was born in 1894, the younger of two sons of a very comfortable Parisian financier who loved nothing more than to be at home, in the bosom of his family, and who was willing to let his children spend most of their time there, too. As was not uncommon among the rich of that era, Lartigue's training in the three R's came through tutors, whose commitments to their own roles, as noted above, were not always monolithic. His real teachers were his parents, two very wise people. They permitted and encouraged him to develop along the lines of his strongest inclination and innate power: the visual recording of passing circumstance.

"My brother Zissou," Lartigue recalls, "had a vivid intelligence and he invented so many things—wooden horses, crates on wheels, even a velodrome—but I was always the little boy, in a way, kept in the corner, dying to take part. This really grieved me, until one day I said to myself, 'Now I am going to catch all these beautiful things which they do.' And I invented my *piège d'oeil*, my eye trap, which consisted in opening and shutting my eyes rapidly three times. This way I had the impression that I caught all of what was going on: the images, the sounds, the colors. All. And since that moment I was happy and soothed because I felt that I had captured and treasured up in my head the essential pictures of the best moments of my day.

"But when after a few days I said to myself, 'Now, let's look back at all the pictures I have stocked away,' it was only to discover that nothing was left of them, or very little."

Lartigue's father had dabbled in the then very raw art of photography, taking pictures just for himself and just for fun. And he must have seen or sensed what was going on in the boy's mind. In a daily journal that little Jacques-Henri kept at the time, and has kept ever since, there is this joyful annotation for a day in 1901: "Papa is like God (as a matter of fact, he might even be God in disguise). He's just told me, 'I'm going to give you your own camera.' Now I will be able to make portraits of everything . . . *everything*. I know very well that many, many things are going to ask me to have their pictures taken, and I will take them all!"

He did indeed. The camera was a ponderous 13 x 18 on a wooden tripod. "It was in waxed wood with a lens extension of grey-green cloth, in accordion folds," he remembers. He also recalls being so small that, even standing on tiptoe, he could not see to focus the instrument. Nonetheless, he lined up part of the household and then: "I climbed on top of a stool. I hid my head under a black cloth; I uncapped the lens, I focused, I counted, I recommended to everybody to keep still and then I put the cap back, and there was the picture!"

For reasons known only to Lartigue, this first picture has never been shown to the public. But the second photograph is ours to savor, the gentle, strong and loving portrait of his mother and father reproduced on page 13. "Photography is a magic thing," he scribbled excitedly. "Nothing will ever be as much fun."

From that moment on, anything that came under his eye was fair game—so long as it was pretty, exciting or fun. At home near Paris, he took portraits of his mother, his grandmother, his nurse, cousins, uncles and anyone else who would hold still (not to mention a few who would not). At the round of vacation chalets his father engaged during the long summers in the Auvergne, in the Normandy countryside, at Calais, Dieppe, Biarritz, he recorded the antics of his indefatigably playful family. There was Zissou and a glamorous cousin skidding around a hair-raising turn in one of the bicycle-wheeled land bobsleds the older Lartigue boy was incessantly building. And the same cousin, looking far less glamorous at the climax of a nose dive from a real bicycle. There were somersaults and skating parties, splashing on the beach—and kites, and more kites.

Before he had passed his tenth year, Lartigue, carrying a new, portable hand camera, had reached out far beyond his family circle to record his own special vision of the delightful sweep of La Belle Époque. He became fascinated by the beautiful women, with their elegant escorts, who took the air each morning in the Bois de Boulogne, and he followed them for gala afternoons at the race track. From brother Zissou's kites it was only a short, thrilling step to the real flying machines of the day, piloted by such legendary pioneers as Blériot, the first man ever to soar over the English Channel in a heavier-than-air machine. From Zissou's bobs, too, it was another simple step to picture the glamorous knights of the road who drove their snorting Panhards and Peugeots in the automobile derbies of the day at Dieppe and Orléans.

Lartigue loved the speed and power of all these new machines, whether they roared across the land or through the air. But though they intrigued him, they did not dominate his attention; they merely expanded the size of the world he could record. As he grew older, acquired new equipment, and learned more and more about the techniques of photography, he made no effort to publicize his pictures or to make money from them. Quite the contrary. He photographed only for his own amusement and satisfaction, and all the results went into private albums, lovingly catalogued and annotated. "I did try to show my pictures around in the early 1950's," he once admitted. Not really out of vanity, however, or any desire for renown:

simply "because it seemed to me there was quite a lot of them. But most publishers and museum curators just looked at them the way one would a toothpick during a meal."

Then, through the combined efforts of his agent, Charles Rado of New York and *Life* magazine, a small selection of Lartigue's work was printed in 1963. There quickly followed a one-man exhibit at the Museum of Modern Art in New York. In the dozen years since, his reputation has spread around the world as perhaps the foremost visual recorder of his era. Yet none of this has had any impact on Lartigue himself. "I feel as though I had won at cards," he says. "If I had lost I would still play tomorrow. Recognition lets me ride in fancy cars, stay in fancy hotels. But that's all. It's very nice, and not important."

Nor has recognition had the slightest effect on his work. He is still a highly personal photographer who takes pictures for himself. And his technique remains essentially what it was when he started as a small boy—that of the instinctive snapshot. There is neither art nor artifice, contrivance nor pretension to any of his pictures. Since he has moved into the public eye, a number of critics, interviewers and even other photographers have tried to attach some mystique to what Lartigue does. But he is very impatient with such puffery. When asked whether he thought photography could be labeled art, he replied, "That is ridiculous and vain. Everything is art; nothing is art. A cook, a shoemaker, a hairdresser are all artists according to how talented they are."

In fact, he has little patience with the whole genre of photographic analysis and criticism. "To talk about photos rather than making them seems idiotic to me. It's as though I went on and on about a woman I adored instead of making love to her."

By making pictures of what he loves most, Lartigue, at eighty-three, goes right on making love to the world.

Ezra Bowen

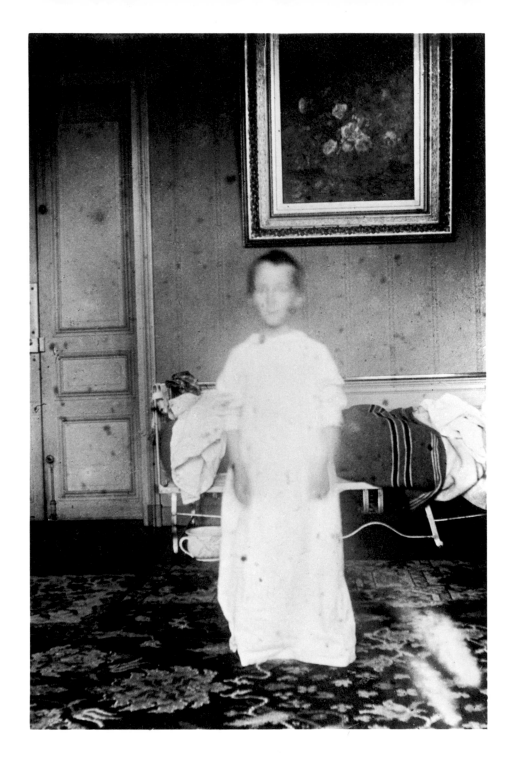

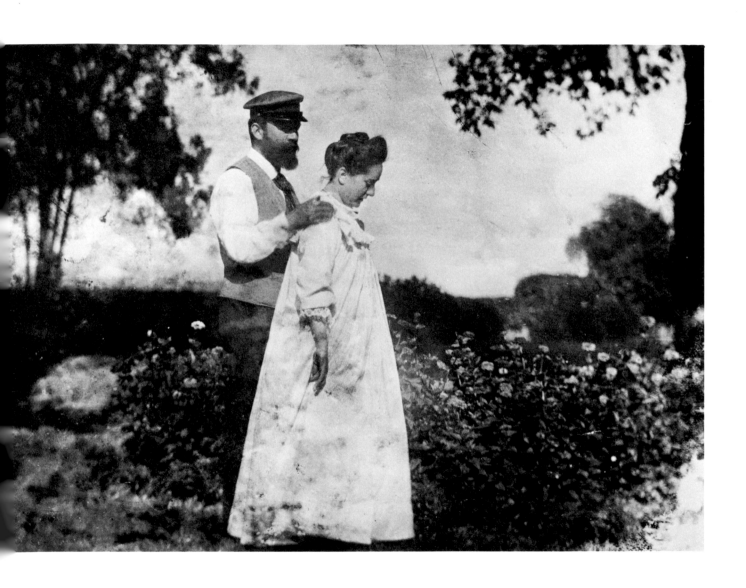

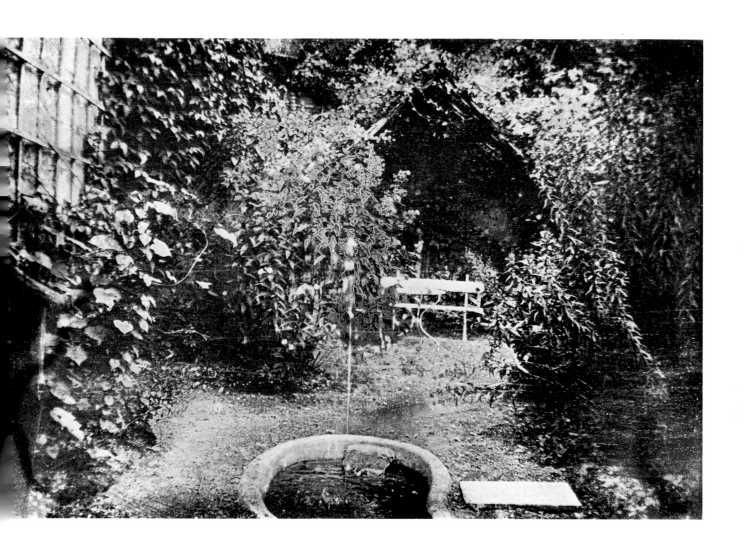

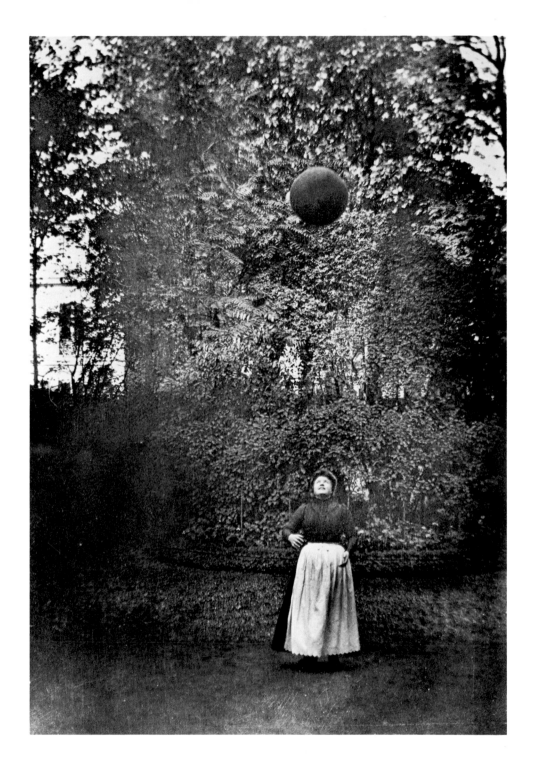

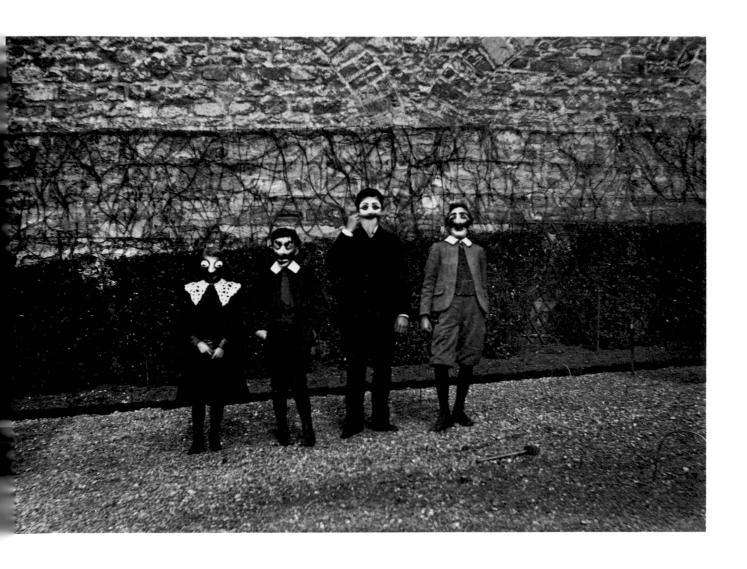

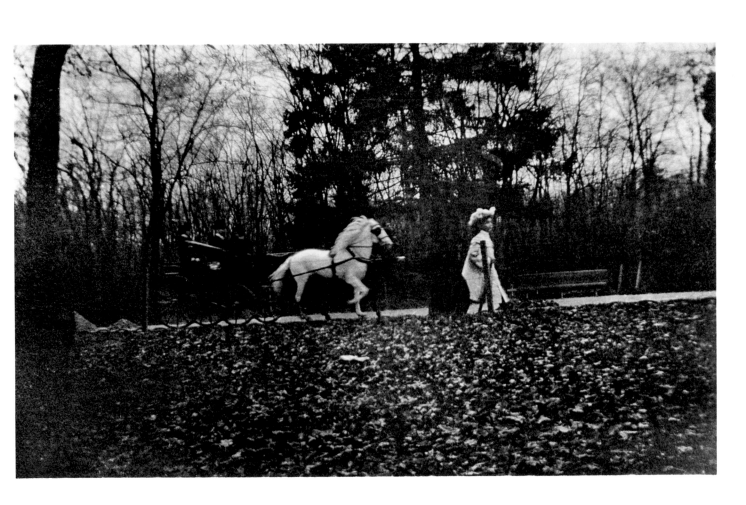

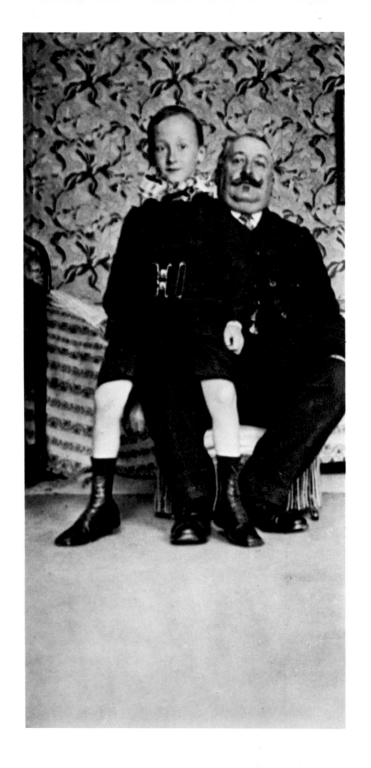

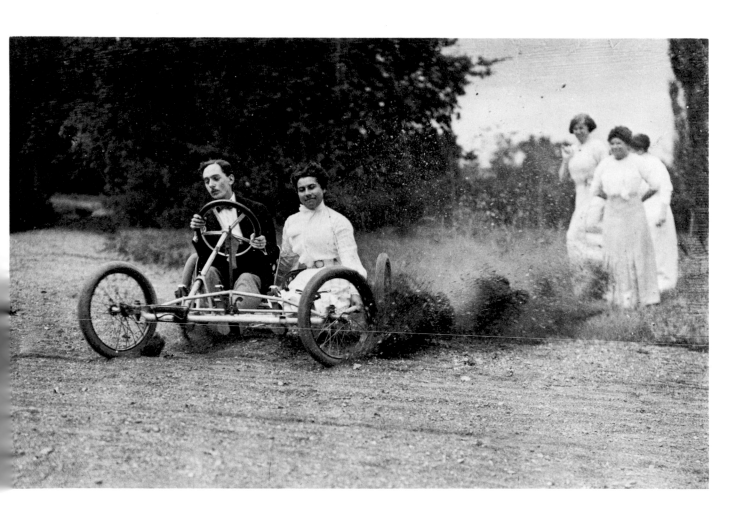

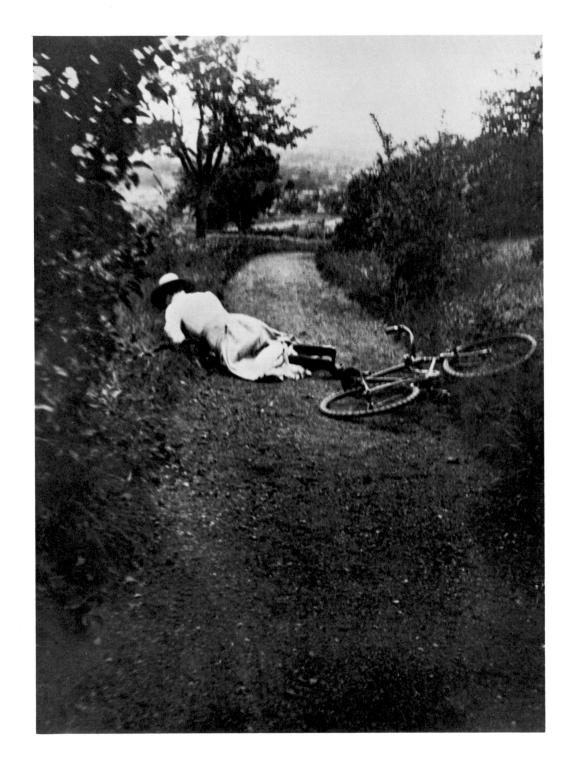

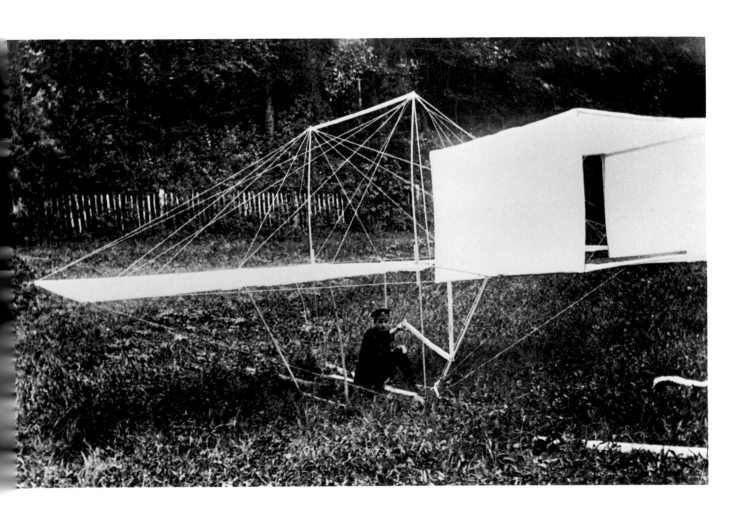

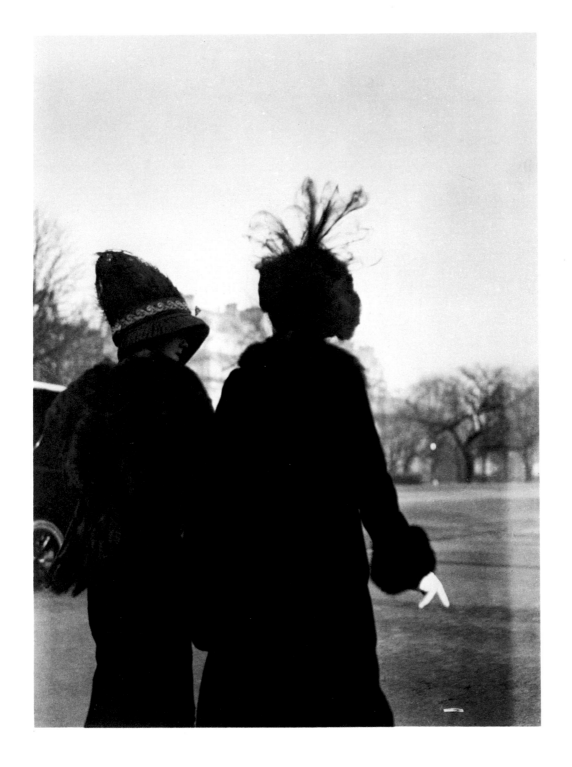

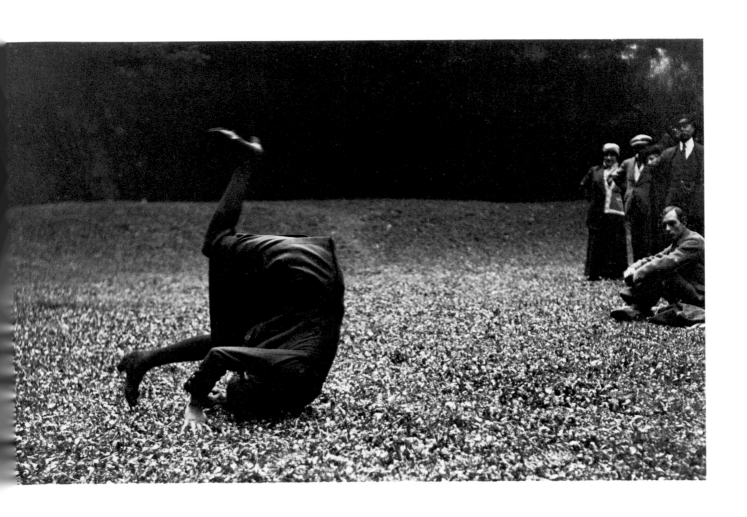

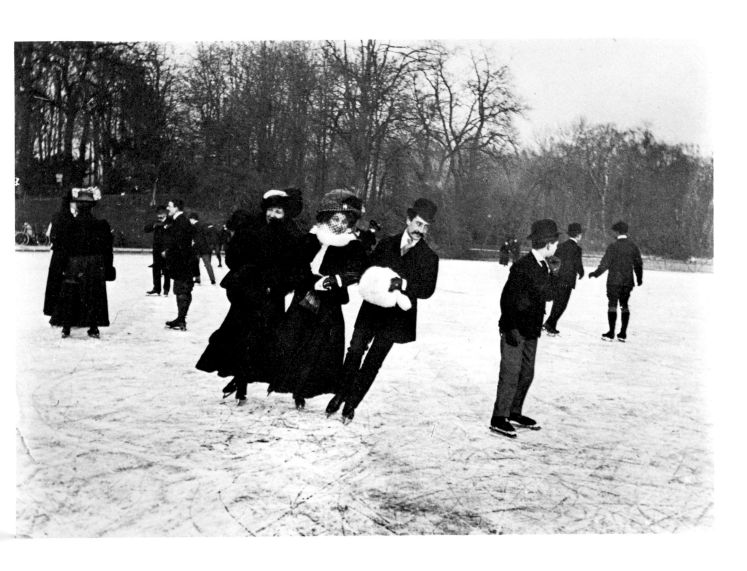

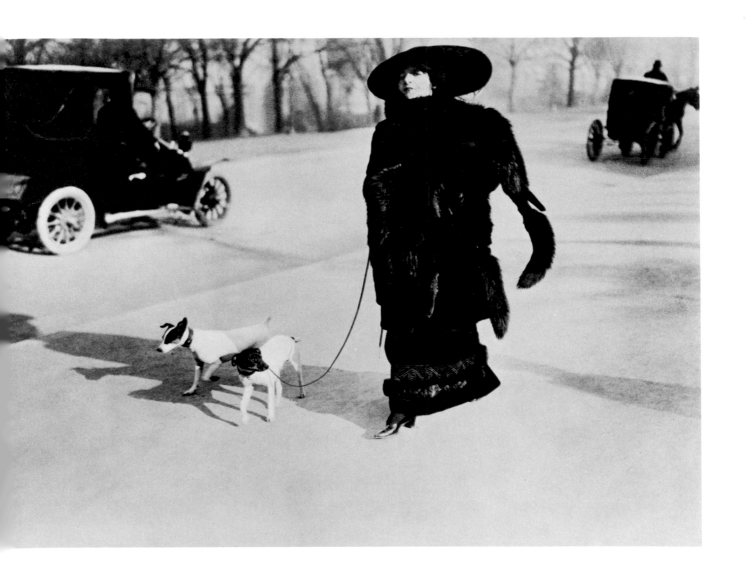

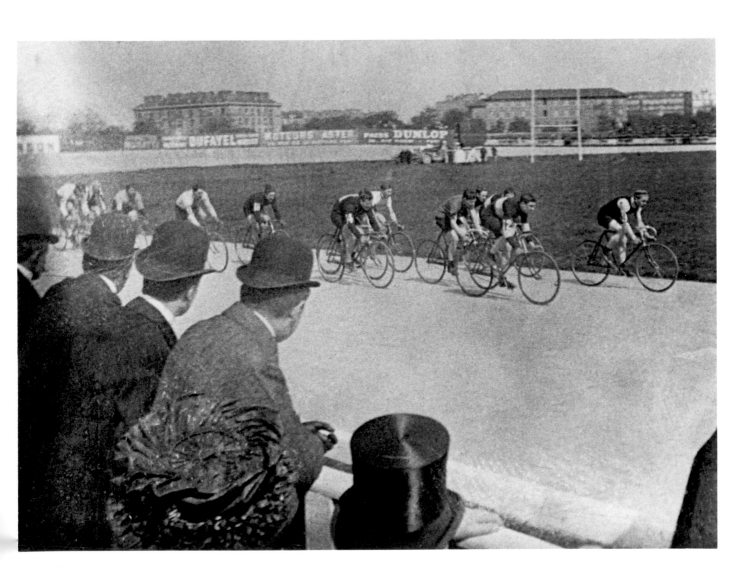

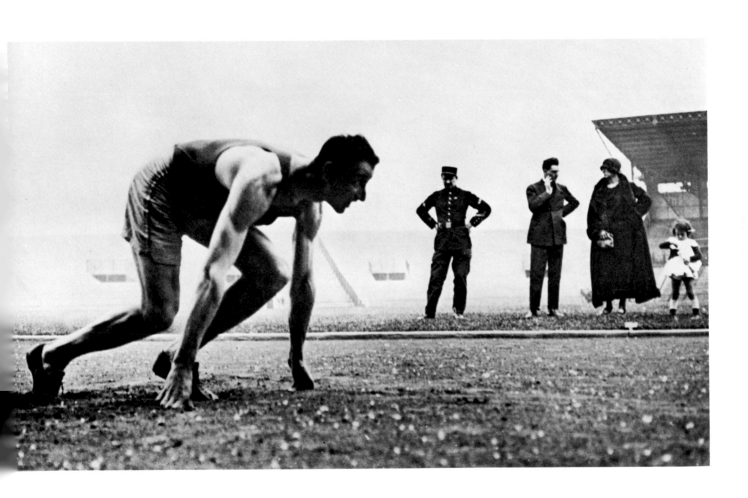

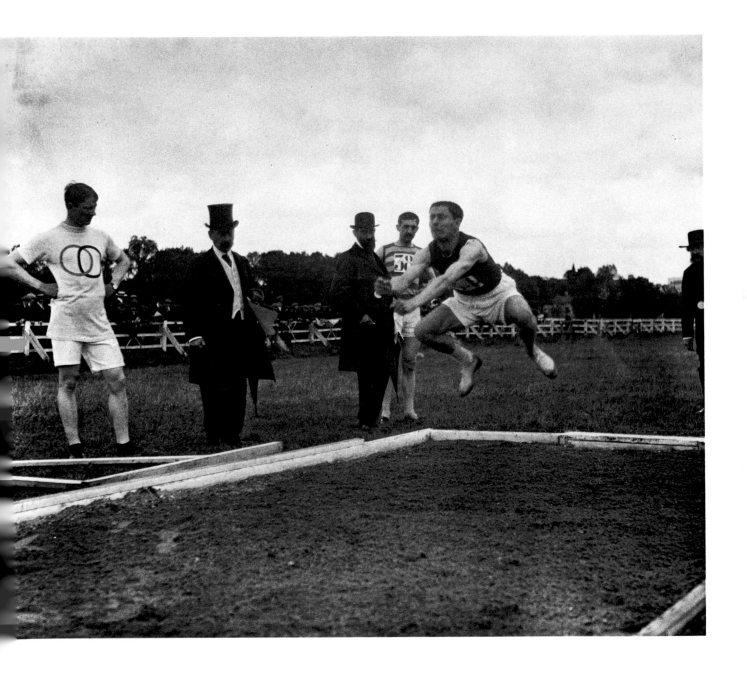

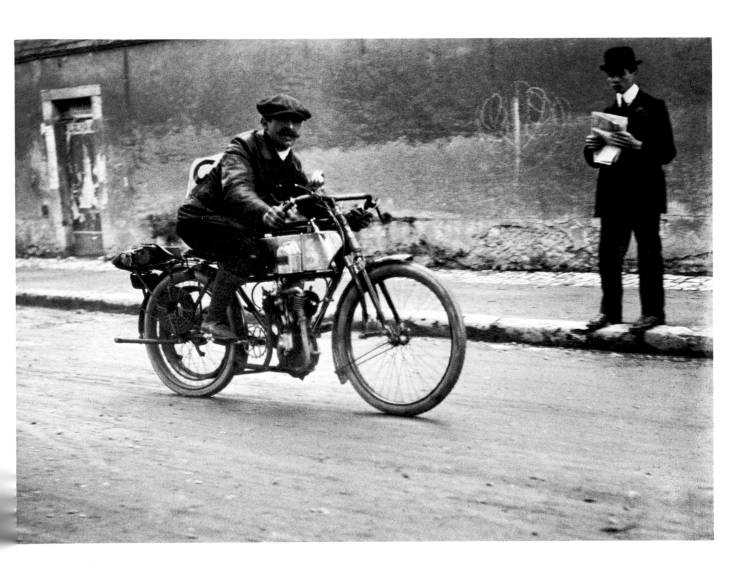

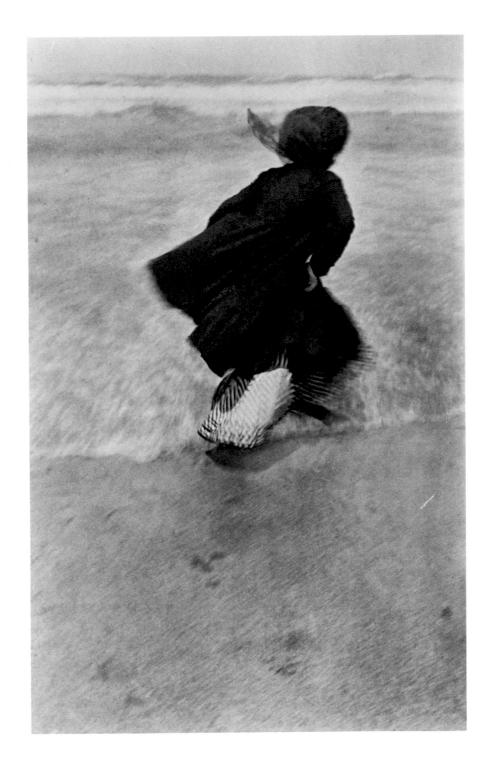

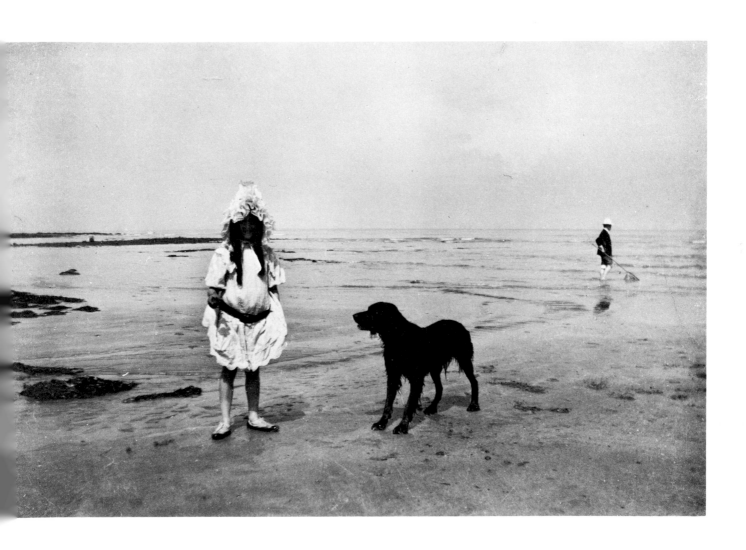

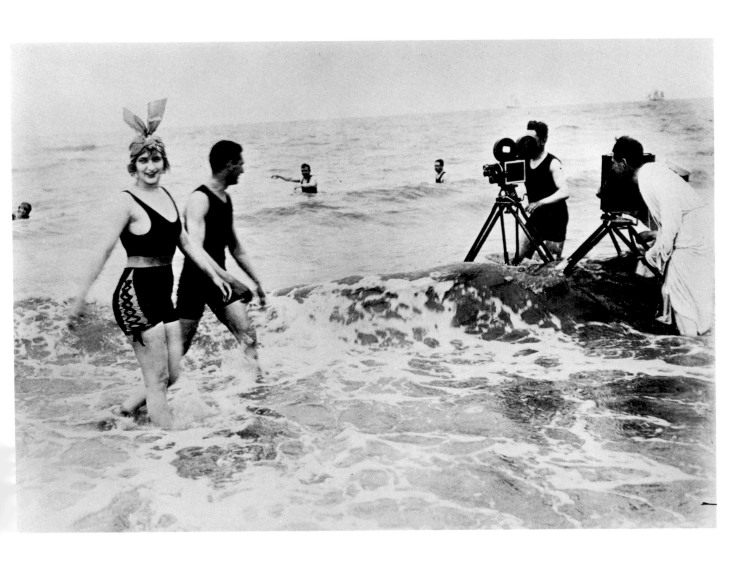

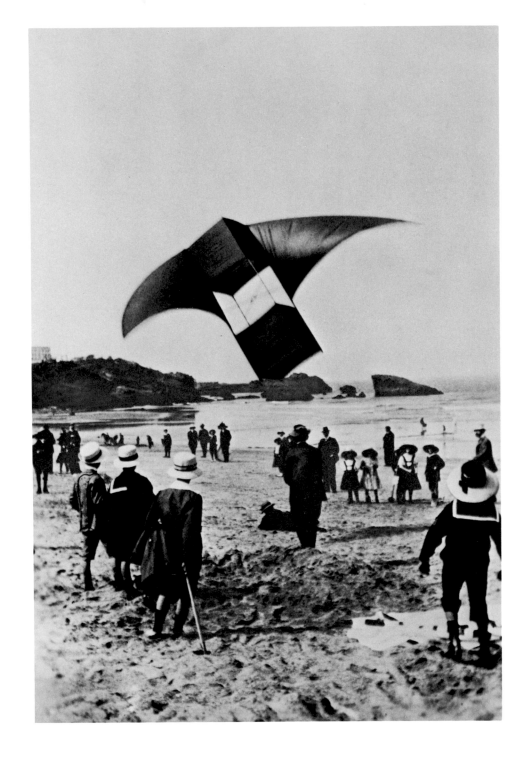

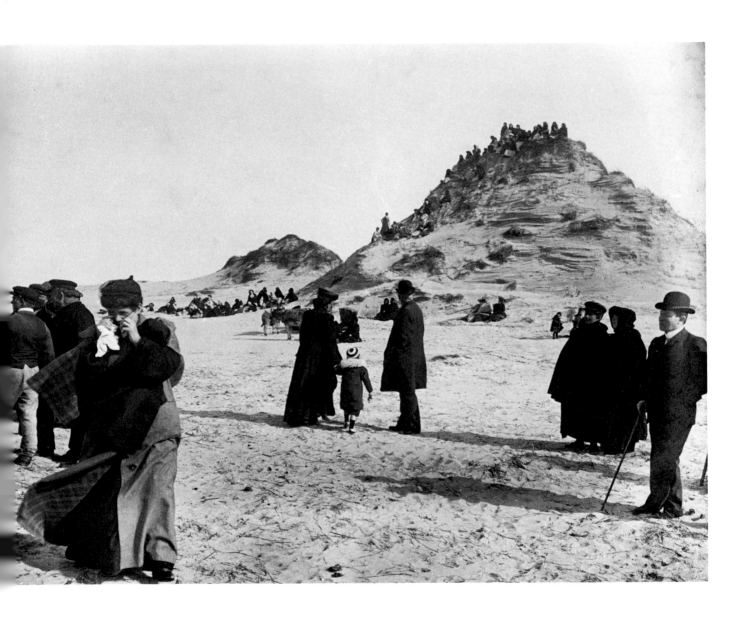

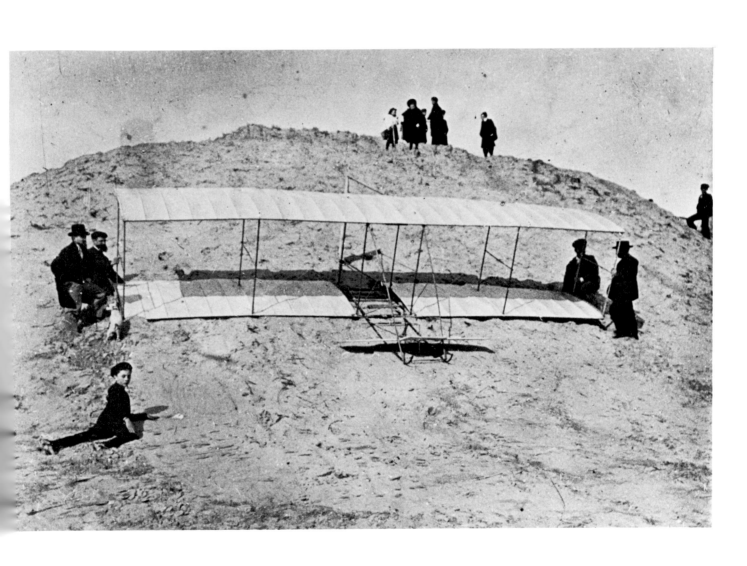

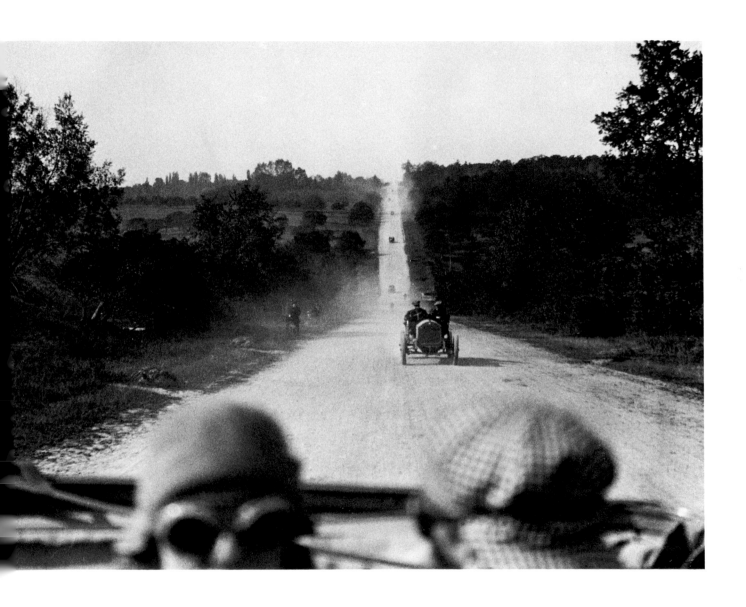

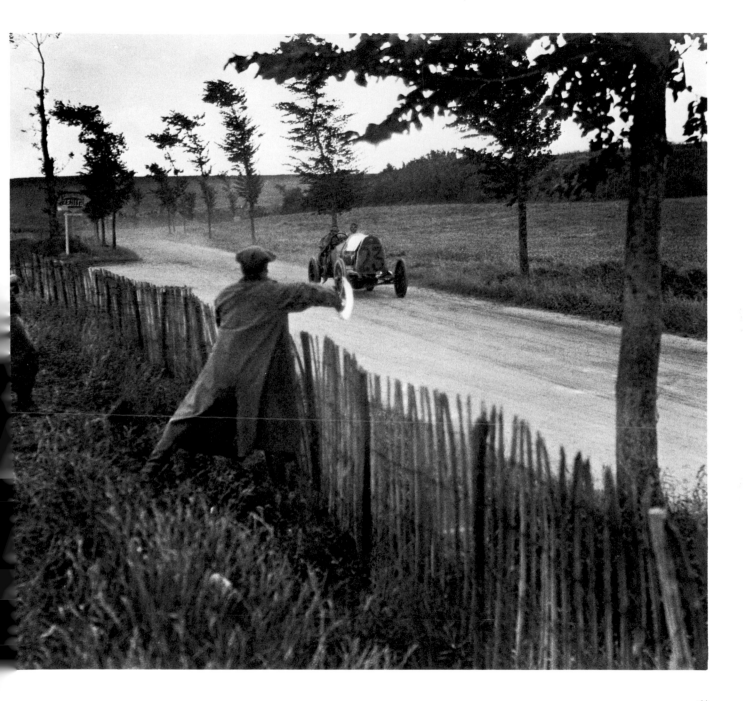

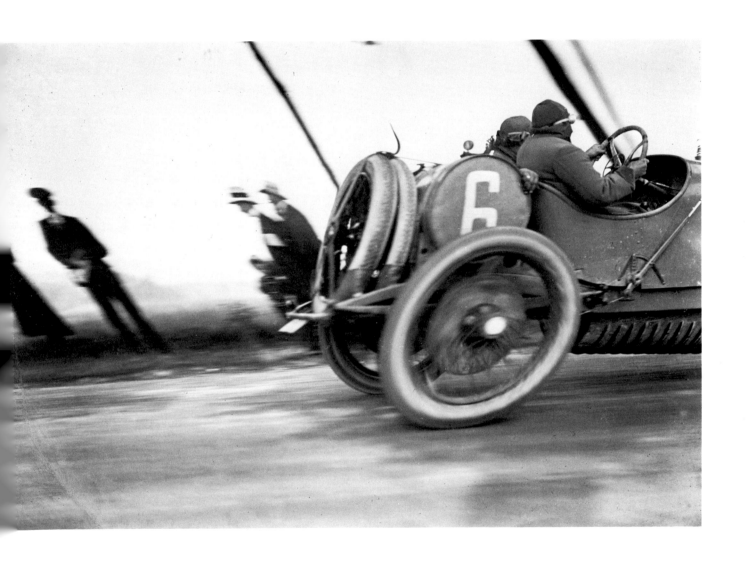

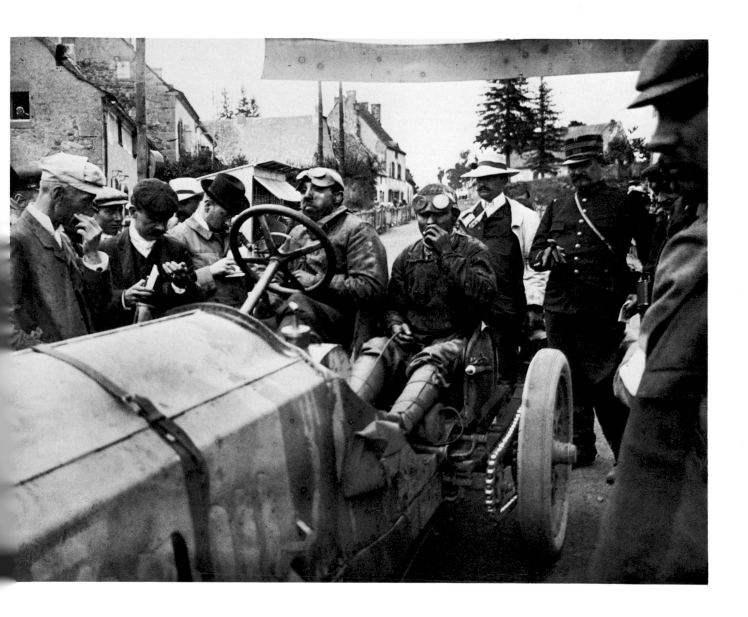

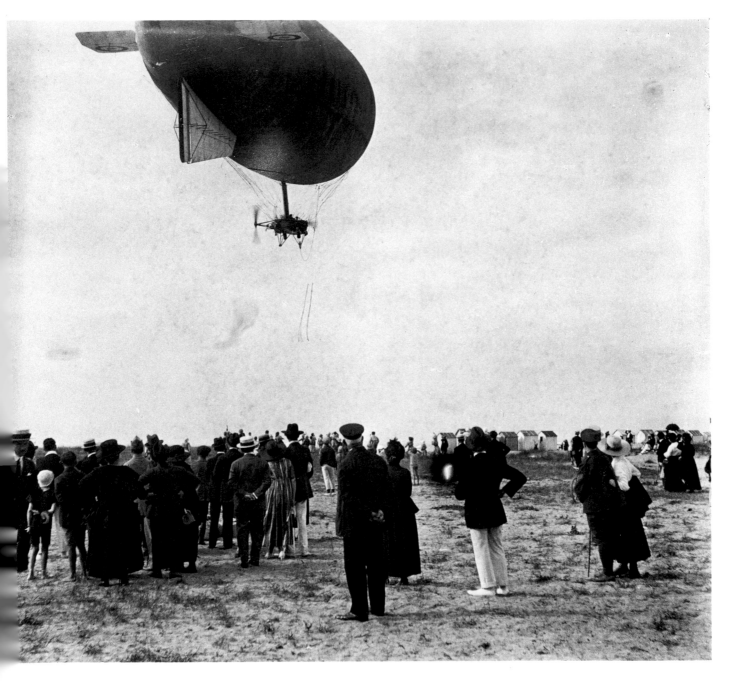

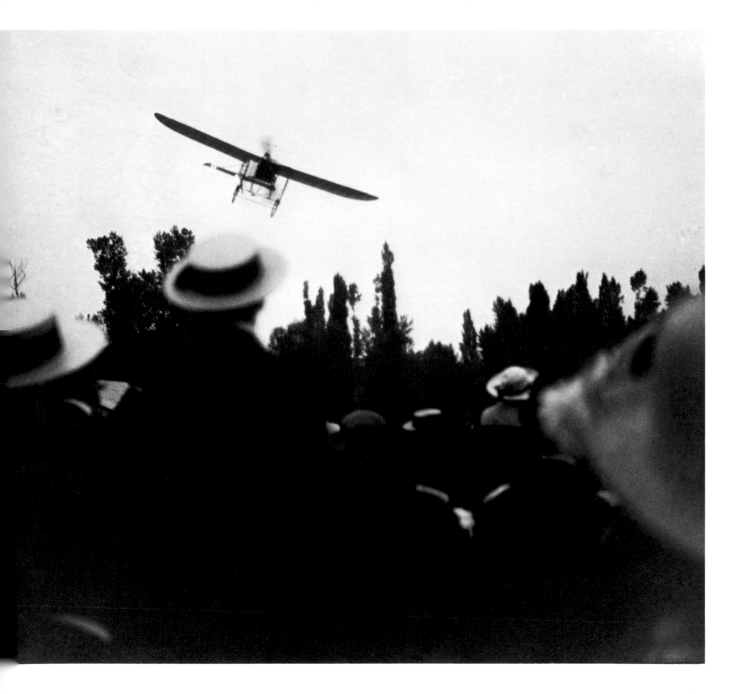

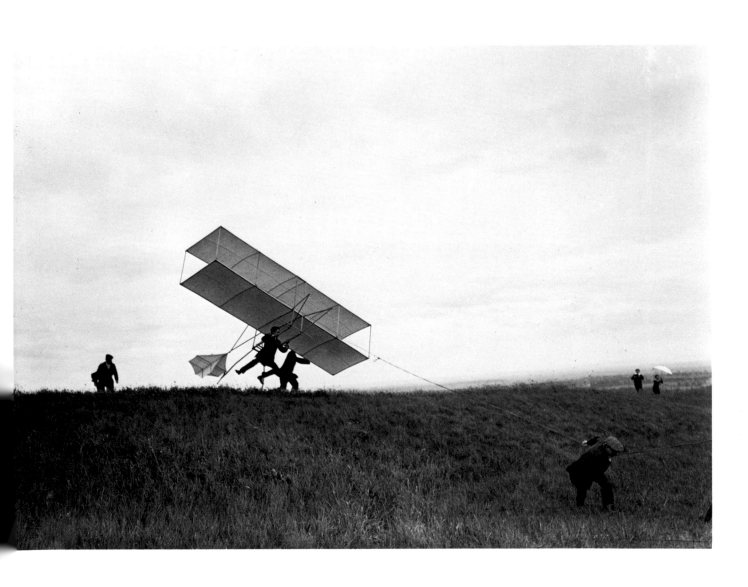

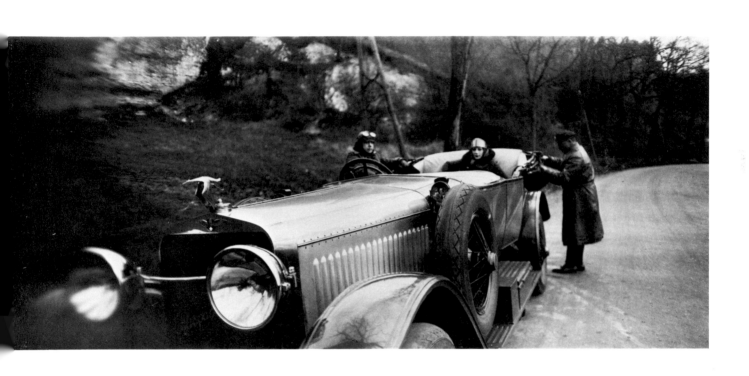

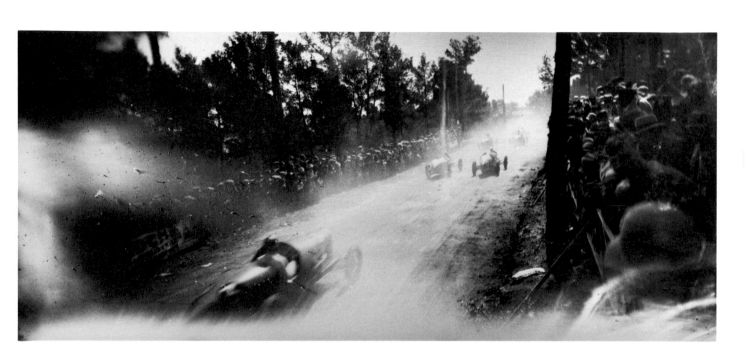

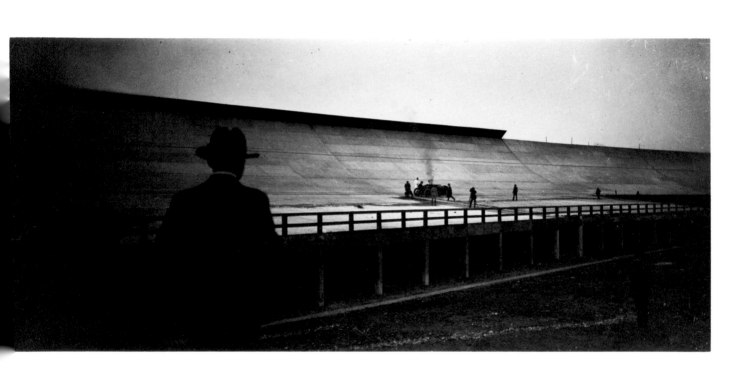

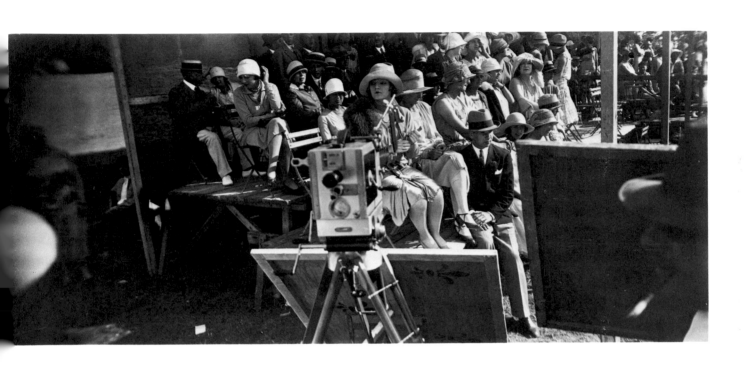

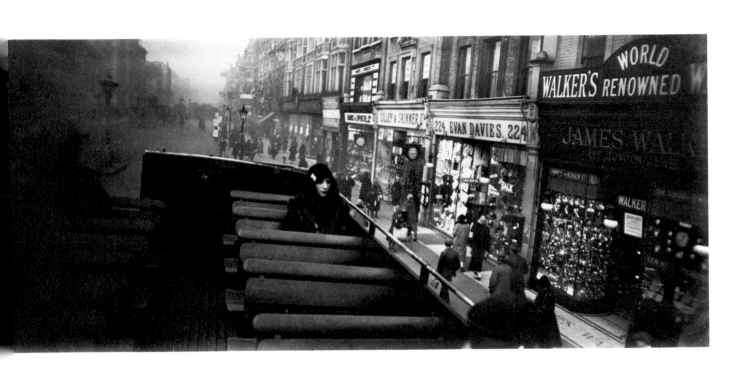

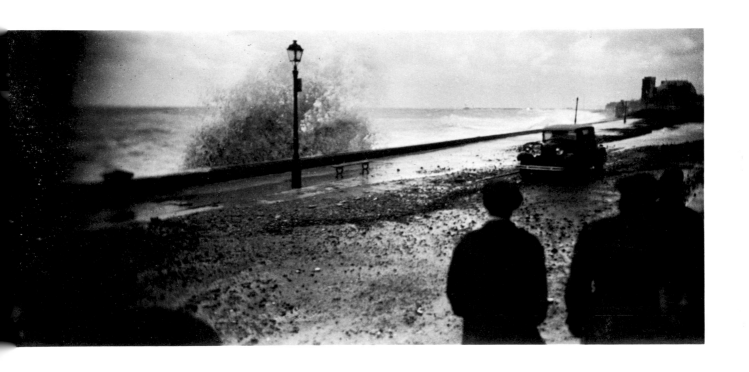

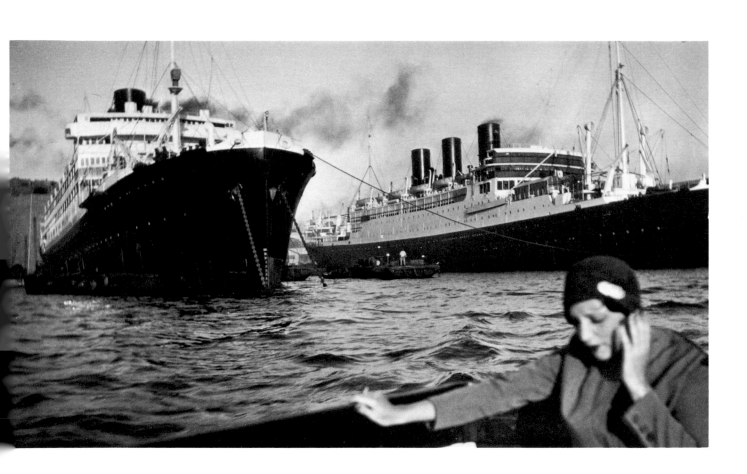

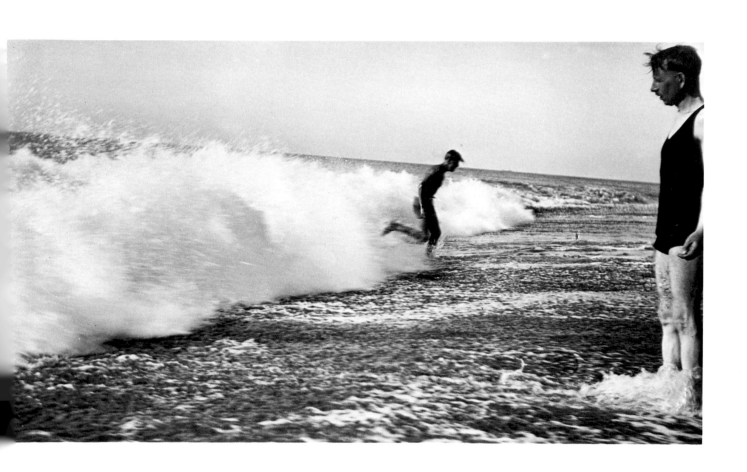

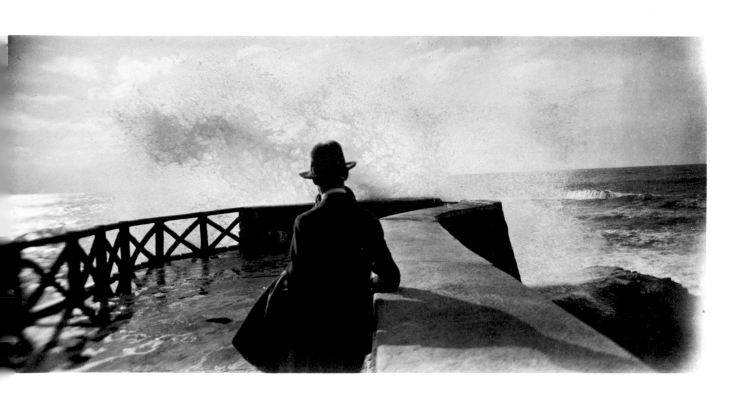

PHOTOGRAPHS

BRIEF CHRONOLOGY

1894. J.-H. Lartigue is born June 13 in Courbevoie, into an upper-middle-class family.

1901. His father, Henri Lartigue, amateur photographer, makes him a gift of his first camera.

1902. Takes first photograph (since then, has taken over 200,000); begins his diary, illustrated with sketches, a kind of sister chronicle to the photographs; witnesses with his family the rapid development of the automobile and the airplane (his brother Zissou, encouraged by the success of Wright and Voisin, constructs glider planes).

1912. Has his first film camera; makes several short films between 1913 and 1914.

1915. Goes to school at the Académie Julian, where he is a student of J.-P. Laurens; completes his first painting in oil.

1916. Is rejected by the army at the beginning of the war; finally manages to enlist.

1919. Marries Bibi Messager, daughter of André Messager, composer, orchestra director and director of the opera; devotes himself to painting, which becomes and remains his principal public activity, and shows in numerous salons and galleries (Bernheim Jeune, Paris, 1933, 1934, 1935, and Charpentier, Paris, 1939); becomes friends with many artists, people of letters and the theater (Van Dongen, Colette, Yvonne Printemps, Sacha Guitry, Jean Cocteau, Maurice Chevalier, Picasso).

1942. Marries Florette Orméa.

1952–65. Has numerous shows of his paintings in France and New York (Knoedler Gallery); photographs the shooting of films by directors such as Jean Renoir, Abel Gance, Robert Bresson, François Truffaut.

Since 1960. Lives in Paris and in Opio, near Grasse.

1963. His photographs have a first public showing at the Museum of Modern Art in New York.

SELECTED BIBLIOGRAPHY

The Photographs of Jacques-Henri Lartigue. Catalogue of the Museum of Modern Art show in New York, 1963. Introduction by John Szarkowski.

The Photographs of J.-H. Lartigue (*Les photographies de J.-H. Lartigue*). A family album of the Gay Nineties, with introduction by Jean Fondin. Ami-Guichard-Edita, Lausanne, 1966. English edition: *Boyhood Photo of J.-H. Lartigue: The Family Album of a Gilded Age.* Guichard-Time-Life Books, New York.

Diary of a Century. Conceived and presented by Richard Avedon. Viking Press, New York, 1970; Weidenfeld & Nicholson, London, 1971. German language edition: *Photo-Tagebuch unseres Jahrhunderts,* Bücher Verlag, Lucerne, 1971. French edition: *Instants de ma vie.* Éditions du Chêne, Paris, 1973.

Portfolio J.-H. Lartigue. Ten original photographs signed by the author. Limited edition of 50 copies. Introduction by Anaïs Nin. Witkin-Berley Ltd., New York, 1972.

J.-H. Lartigue and Women (*J.-H. Lartigue et les femmes*). Photographs and text by J.-H. Lartigue. Éditions du Chêne, Paris, 1973. English edition: Studio Vista, London; Dutton and Co., New York, 1974.

Das Fest des Grossen Rüpüskül. Text by Elisabeth Borchers. Photographs by J.-H. Lartigue. Insel Verlag, Frankfurt am Main, 1973.

J.-H. Lartigue and Cars (*J.-H. Lartigue et les autos*). Photographs and text by J.-H. Lartigue. Éditions du Chêne, Paris, 1974.

Memoirs without Memory (*Mémoires sans mémoire*). Excerpts from J.-H. Lartigue's diary. Éditions du Chêne, Paris, 1975.

Lartigue 8 x 80. Catalogue of exhibit organized by the CCI at the Museum of Decorative Arts in Paris. Delpire Éditeur, Paris, 1975.

EXHIBITIONS

1963. First exhibition at Museum of Modern Art, New York.

1966. Large exhibition at the Photokina, Cologne.

1970. Exhibition at the Photographer's Gallery, London. From 1970 to 1973, this show toured many cities throughout England, then went to France (la Vieille Charité in Marseilles, 1972; la Maison de la Culture du Havre, 1972) and to Germany (Museum für Kunst und Gewerbe, Hamburg.

1971. Several J.-H. Lartigue photographs are presented at the exhibition "Recent Additions to the Photographic Collection of the Prints Department," Bibliothèque Nationale, Paris.

1972. Exhibition at the Neikrug Gallery and at the Witkin Gallery, New York. This double show was re-presented in 1974 by the cinémathèque of Quebec for la Bibliothèque Nationale of Montreal.

1973. Numerous group exhibitions in France (particularly in Dijon, "Confrontation 73") and in the U.S. ("Friends of Photography" in Carmel, California, and at the annual festival in Birmingham, Alabama).

1975. First big French exhibition, Museum of Decorative Arts, Paris.

1976. Exhibition of 189 photographs at the Seibu Art Museum, Tokyo.

FILMS ON J.-H. LARTIGUE

The Magician. By Claude Fayard, Production Coty, 1966.

The Lartigue Family. By Robert Hugues, Production O.R.T.F. for the "Panorama" series, 1970.

J.-H. Lartigue. By Claude Gallot, Production O.R.T.F. for the "Variances" series, No. 19, 1971-72.

J.-H. Lartigue. By Claude Ventura, Production O.R.T.F. for the "Italiques" series, 1974.

Television programs on J.-H. Lartigue have been shown in Germany, England, Sweden, Switzerland and the United States.

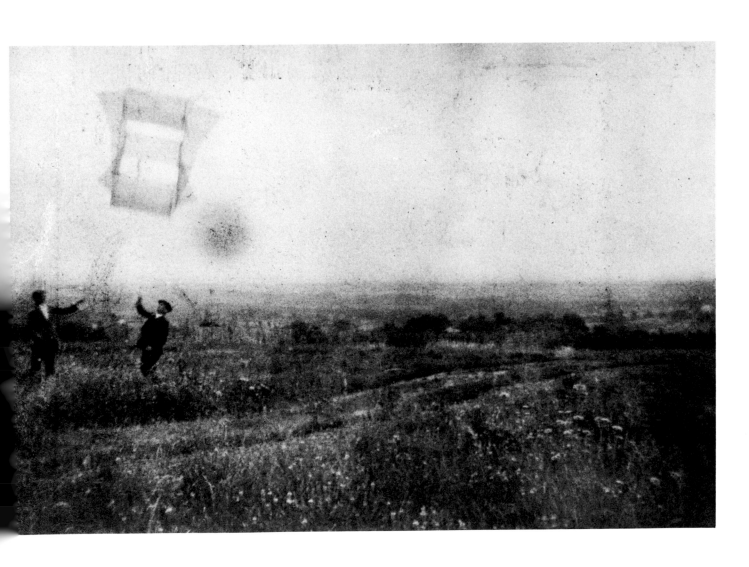

779
Lartique, Jacques-Henri

Jacques-Henri Lartique